Rare Bookplates Ex-Libris Of The Fifteenth And Sixteenth Centuries

Friedrich Warnecke

RARE BOOK-PLATES
(EX-LIBRIS)
OF THE
XV$^{\text{TH}}$ AND XVI$^{\text{TH}}$ CENTURIES,

BY

ALBERT DUERER, H. BURGMAIR, H. S. BEHAM,
VIRGIL SOLIS, JOST AMMAN ETC.

EDITED

BY

FREDERICK WARNECKE.

LIMITED

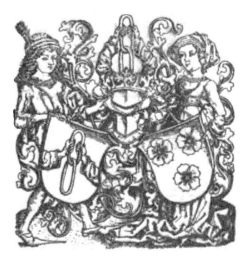

EDITION.

LONDON
H. GREVEL & Co.
33 KING STREET, COVENT GARDEN, W. C.
MDCCCXCIIII.
(PRINTED IN GERMANY.)

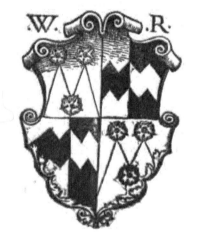

Book-Plate of W. von Rehlingen in Augsburgh.

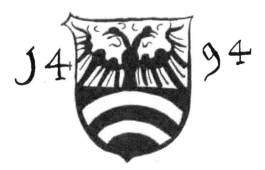

Since the foundation of the Ex-libris Societies in London and Berlin, both of which have already a considerable number of members, it has become evident, that the objects of these two Societies meet with general approval.

The interest in old Book-Plates especially has greatly increased and every amateur is glad, if he can add another rare print of bygone centuries to his collection.

Armorial plates of the 15. 16. and 17. centuries have been found in several Public Libraries, but it has been doubted whether they have really served as Ex-libris, as many of them are of enormous dimensions* compared with our modern plates. This extraordinary size is nevertheless no proof against their having been used as Ex-libris, if we bear in mind, that the books they were to grace were mostly folio. The artist had on this account a better opportunity to produce an elaborate design, than our modern engravers.

Most of these plates bear no inscription whatever and this was another reason for unbelievers to doubt their having been Ex-libris. But it is not a consistent one, as there is no Ex-libris

*) Most of these are given in the «Heraldische Kunstblätter» published by Frederick Warnecke, which contains about 300 coats-of-arms by A. Duerer, Martin Schöngauer, Israel von Mecken, Virgil Solis, Jost Amman etc. 3 Parts Folio. Berlin J. A. Stargardt.

of the 15. century marked as such, and in the beginning and middle of the 16. century there are but few plates which bear inscriptions, as for instance:

«Liber Hieronimi Ebner». «Liber Bilibaldi Pirkheimer».
«Sum ex libris Joannis Hartmanni Junioris Forchemii».

The Ex-libris of the 15. century as far as I know them, are described and partly reproduced in my Handbook of German Ex-libris, for example:

<div align="center">

Chaplain Hans Igler

Friar Hildebrand Brandenburg

Younker Wilhelm von Zell

Younker Bernhard von Rohrbach etc.

</div>

These plates, which undoubtedly have been used as Ex-libris, are in no way marked as such; they show only the arms, once with name, in other cases without.

Recently also Ex-libris of large folio-size, pasted into books, have been found such as:

<div align="center">

Count Maxim. Ludwig Breuner 250×350 mm.

von Pfinzing-Henfenfeld 248×356 mm.

Sebald Millner von Zweiraden 260×373 mm.

Ferdinand Barth von Harmating 316×423 mm.

</div>

There can be no doubt, that many of the plates published in the previously mentioned work («Heraldische Kunstblätter») have been used as Ex-libris; with most of them this is evident at first sight.

Some of the plates which here follow may be doubted as book-plates and I am sorry to say, I have no absolute proof of their original object. On the other hand there is no evidence to the contrary and so I thought it best to include them in this work, the more so as the probability is in favour of their having really served as Ex-libris.

Some of the originals (Plates 4, 6, 7, 8, 16) are not in good condition or have been daubed with colours but I have not restored or retouched them, in order to give as faithful a copy as possible.

The above mentioned «Heraldische Kunstblätter» contain a selection of the best works of the old masters. Very few of the originals are in private hands, most of them are in Museums, Public Libraries etc., and if by chance they occur for sale they are only to be obtained at almost fabulous prices.

For the student of the Ex-libris as well as for those who are interested in heraldry the following plates will therefore be most welcome. They will also serve as models for the artist.

Various reasons prevented me from giving all the plates in the orginal size. But the amateur will find an exact description of them in the «Kunstblätter».

If this little books meets with a favourable reception, it will be an inducement to the editor to continue the work.

<div style="text-align:center">

Frederick Warnecke.

</div>

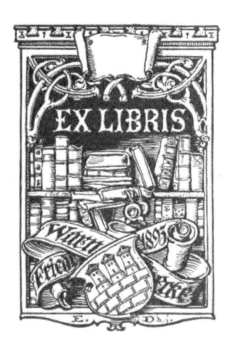

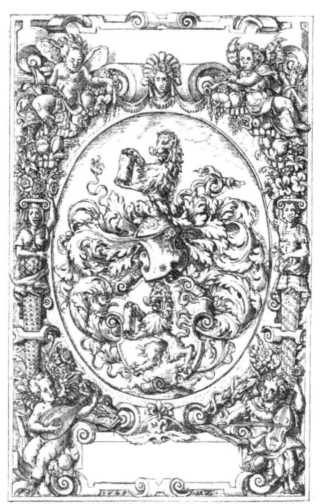

Book-Plate of Wimpheling, by Matthias Zündt, 1568.

List of Book-Plates.

Plate.	Artist.	Made for:	Date.	Original-size.	Warnecke's Herald. Kunstblätter No.
I.	*Albert Dürer.*	Johann Tschertte.	About 1521.	18,5 × 14,2 cm.	37.
II.	*School of Albert Dürer.*	Albr. Scheurl and Anna Zinglin, his wife.	About 1513.	15 × 14 cm.	40.
III.	*Hans Burgmair.*	Joh. Saganta.		45 × 29 cm.	130.
IV.	*The same.*	Martin Graf of Oettingen.		34 × 22,8 cm.	204.
V.	*Unknown Master.*	Dr. Joh. Eck, Adversary of Luther.		16,7 × 11 cm.	208.
VI.	*Ditto.*	Leopold Dickius ab Hiltprantseck.		43,5 × 33,4 cm.	134.
VII.	*Ditto.*	Joh. Scheiring of Magdeburg.		19,2 × 14,2 cm.	228.
VIII.	*Michael Ostendorfer.*	Peter Apian.	About 1534.	40,2 × 28,8 cm.	233.
IX.	*Hans Sebald Beham.*	Hans Sebald Beham himself.	1544.	5³/₄ cm. diam.	65.
X.	*Monogrammist S. F.*	Gabriel Schlüsselberger.	1575.	8,5 × 6,8 cm.	250.

Plate.	Artist.	Made for:	Date.	Original-size.	Warnecke's Herald. Kunstblätter No.
XI.	*Unknown Master.*	Wolf Haller.	1551.	23×16,7 cm.	152.
XII.	*Ditto.*	Dr. jur. Laurentius Hochbart.		9 cm. diameter.	251.
XIII.	*Augustin Hirschvogel.*	Lassla of Edlasperg, K. K. Rath.	1545.	27,8×18,5 cm.	68.
XIV.	*Hans Sebald Lautensack.*	Joh. Neudörffer and Katharina Sidelmann his 2. wife.		20,75×12,75cm.	70.
XV.	*Jost Amman.*	von Holzschuher.		18,9×15,6 cm.	79.
XVI.	*Monogrammist A. F. (Adam Fuchs.)*	Hieronymus Köhler and ?, his wife.		25,2×18 cm.	260.
XVII.	*Jost Amman.*	Julius Geuder of Heroldsberg.		11,2×7,3 cm.	257.
XVIII.	*Unknown Master.*	Martin Clostermayr, Med. Dr.	1579.	21,8×19,6 cm.	240.
XIX.	*Ditto.*	Fabritz and his wife, née Ehen.		13×8,7 cm.	261.
XX.	*Andreas Kohl.*	von Pfinzing-Gründlach.		35,5×24,8 cm.	188.

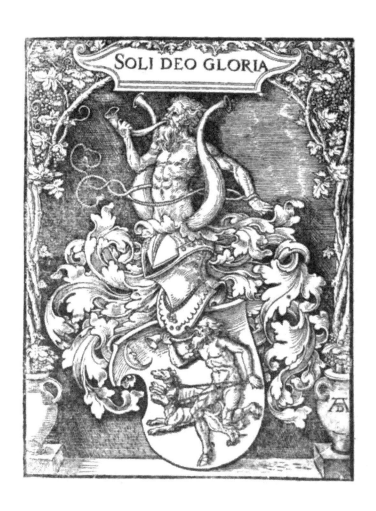

SOLI DEO GLORIA

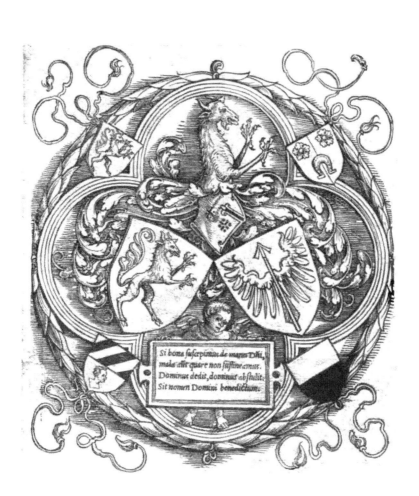

Si bona suscepimus de manu Dni,
mala dñr quare non sustineamus.
Dominus dedit, dominus abstulit:
Sit nomen Domini benedictum.

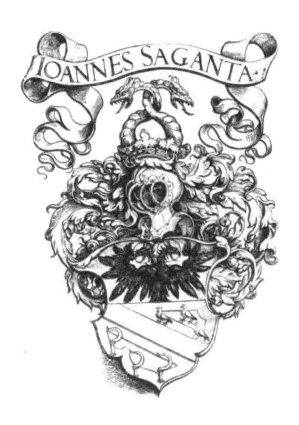

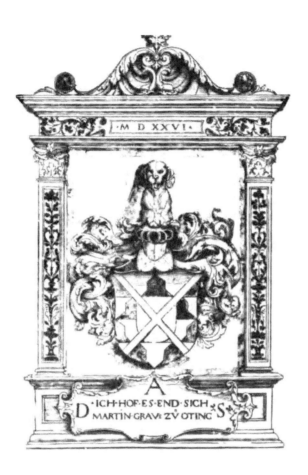

· M · D · XXVI ·

A
D · ICH · HOF · ES · END · SICH S
MARTIN · GRAVI · ZV · OTING

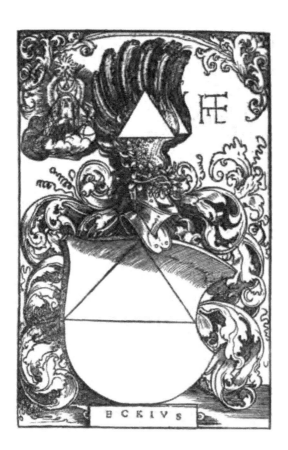

ECKIVs

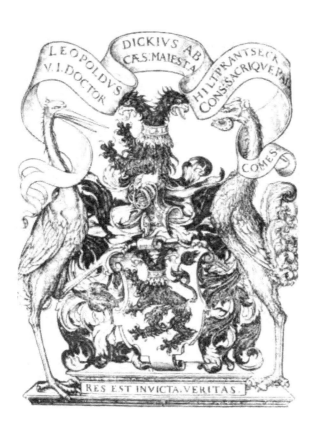

LEOPOLDVS V. I. DOCTOR DICKIVS AB CÆS: MAIESTA HILTPRANTSECK CONS: SACRIQVE PAL. COMES

RES EST INVICTA. VERITAS.

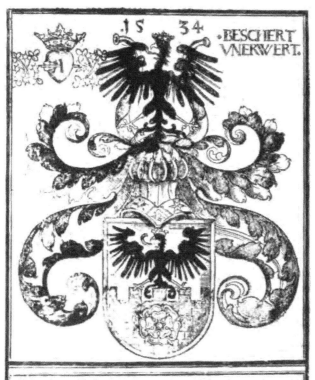

1 5 34 ✠ BESCHERT
VNERWERT.

Joannes scheiring Magdeburgensis Patricius eques
Auratus Viccomes palatinus Artium et v. J. Doctor.

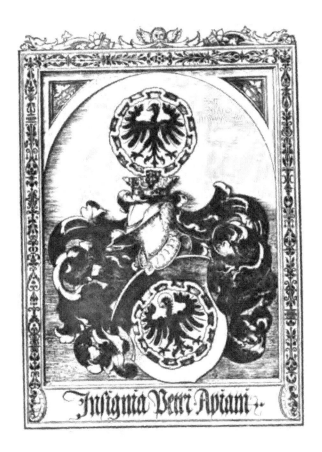

Insignia Petri Aviani

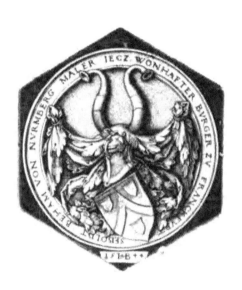

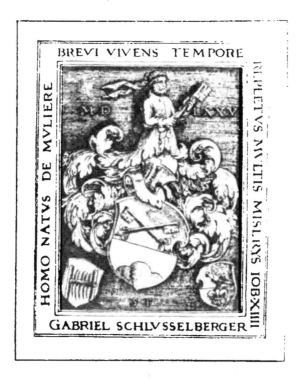

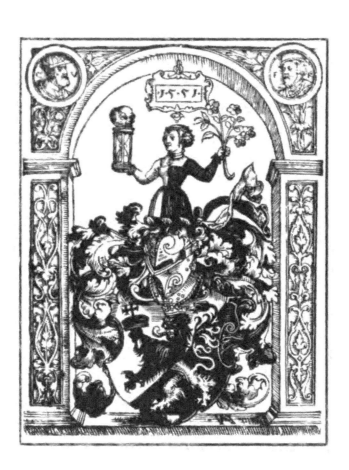

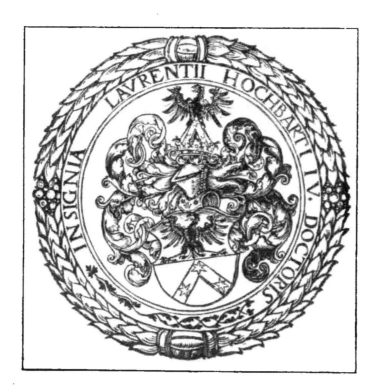

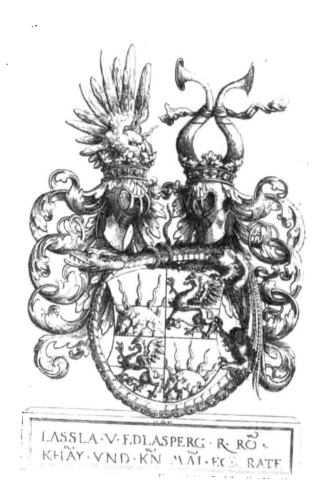

LASSLA · V · EDL ASPERG · R · RÖ ·
KHÄY · VND · KN · MAI · EC · RATE

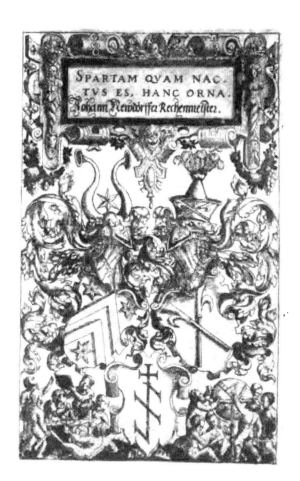

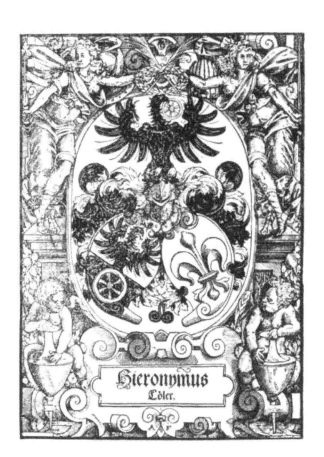

Hieronymus
Edler.

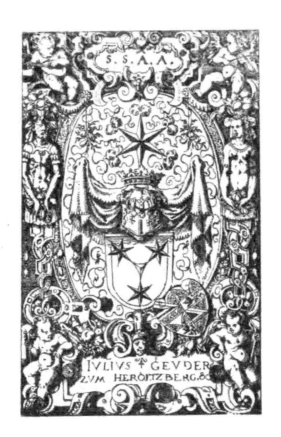

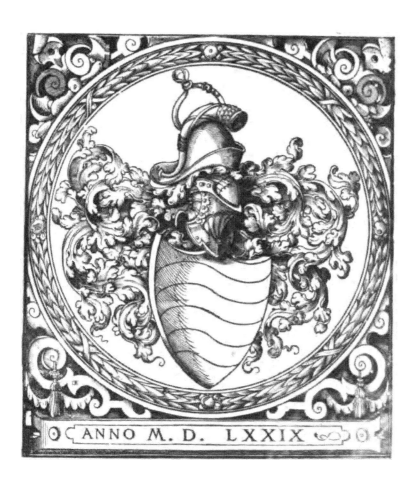

ANNO M. D. LXXIX

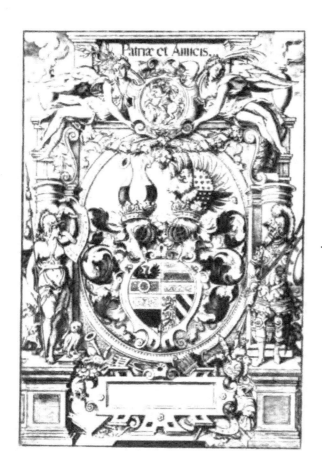

BOOKS ON EX-LIBRIS

PREVIOUSLY PUBLISHED BY

Messrs. H. GREVEL & Co., LONDON

33, KING STREET, COVENT GARDEN W.C.

Hildebrandt, Ad. M., HERALDIC BOOK-PLATES. 25 EX-LIBRIS. Volume I. 8⁰. (Edition limited to 50 copies. Out of print.) **(4/— net.)**

— Volume II. 8⁰. (Edition limited to 100 copies.) **4/— net.**

Kissel, Clemens, SYMBOLICAL BOOK-PLATES. 25 EX-LIBRIS. 8⁰. (Edition limited to 100 copies.) **4/— net.**

Otto, George, A SCORE OF BOOK-PLATES. 8⁰. (Edition limited to 100 copies.) **4/— net.**

Teske, Charles, THE BOOK-PLATES OF ULRICK DUKE OF MECKLENBURGH, WOODCUTS BY LUCAS CRANACH AND OTHER ARTISTS, BESIDES SEVERAL EX-LIBRIS OF SOME OTHER MEMBERS OF THE MECKLENBURGH DYNASTY. Folio. (Edition limited to 200 Copies.) **3/— net.**

IN PREPARATION:

Sattler, Joseph, ART IN BOOK-PLATES. 42 Original Ex-Libris mostly coloured. Limited Edition. About **£1/10,—**

Monogram-Book-Plate E. G. (XVI. Century.)

RARE BOOK-PLATES
(EX-LIBRIS)
OF THE
XV$^{\text{TH}}$ AND XVI$^{\text{TH}}$ CENTURIES,
BY
ALBERT DUERER, H. BURGMAIR, H. S. BEHAM,
VIRGIL SOLIS, JOST AMMAN ETC.
EDITED
BY
FREDERICK WARNECKE.
SECOND SERIES.

LIMITED *EDITION.*

LONDON
H. GREVEL & Co.
33 KING STREET, COVENT GARDEN, W.C.
MDCCCXCIIII.
(PRINTED IN GERMANY.)

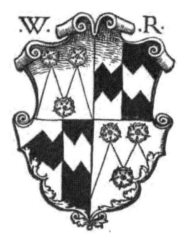

Book-Plate of W. von Rehlingen in Augsburgh.

Plate.	Artist.	Made for:	Date.	Original-size.	Warnecke's Herald. Kunst-blätter No.
XXI.	*Barthel Schoen?*	Bernhard von Rohr-bach and his wife Eilke, née von Holz-hausen at Frankfort.	(1466)	9,7×9,3 cm.	20.
XXII.	*Unknown Master.*	C. von Venningen.	148.	5,2×4,7 cm.	198.
XXIII.	*Albert Duerer.*	Johann Stabius, Historiographer of Emperor Maxi-milian I.	(1521)	27,5×19 cm.	35.
XXIV.	*Ditto.*	Johann Stabius.	151.	29,5×19,1 cm.	36.
XXV.	*Ditto.*	Kress von Kressen-stein.	152.	32,5×26,9 cm.	116.
XXVI.	*Unknown Master.*	Balthasar von Lam-berg, Chaplain and Archdeacon at Salzburgh.	1529	37,3×27,2 cm.	126.
XXVII.	*School of Albert Duerer.*	Rehm. (Augsburgh Pa-trician.)	1526	20,2×17,8 cm.	45.
XXVIII.	*Unknown Master.*	Unknown.	152.	11,5×9,3 cm.	203.
XXIX.	*Hans Sebald Lautensack.*	Eck von Kelheim and his wife, née von Pienzenau.	1552	33,5×25 cm.	69.
XXX.	*Monogrammist M. S.*	Hans Helfrich.	1581	16×10,8 cm.	178.

Plate.	Artist.	Made for:	Date.	Original-size.	Warnecke's Herald. Kunstblätter No.
XXXI.	*Conrad Saldoerfer.*	Held von Hagelsheim and his first and second wifes, nées Römer and Ebner.	15..	27×17 cm.	76.
XXXII.	*Unknown Master.*	Ludwig Häusner.	15..	31×19 cm.	265.
XXXIII.	*Matthias Zuendt.*	von Pfinzing-Gründlach. (Nuremberg Patrician.)	1569	15,3×10,8 cm.	77.
XXXIV.	*Jost Amman.*	Haller von Hallerstein. (Nuremberg Patrician.)	15..	10,7×7,2 cm.	258.
XXXV.	*Hans Sibmacher.*	Pfaudt. (Nuremberg family.)	159.	10,8×7,5 cm.	91.
XXXVI.	*Heinrich Ulrich.*	von Imhof. (Nuremberg Patrician.)	15..	15,9×11,9 cm.	97.
XXXVII.	*Unknown Master.*	von Wurmser.	15..	22×15,5 cm.	264.
XXXVIII.	*Ditto.*	vom Hoff. (Schöning, Grüter and Warnecke.)	1598	21,7×17,2 cm.	—
XXXIX.	*Heinrich Ulrich.*	Gabriel Schlüsselberger.	1594	12,5×8,3 cm.	—
	Georg Huepschmann.	Schrort.	159.	14,2×10 cm.	—

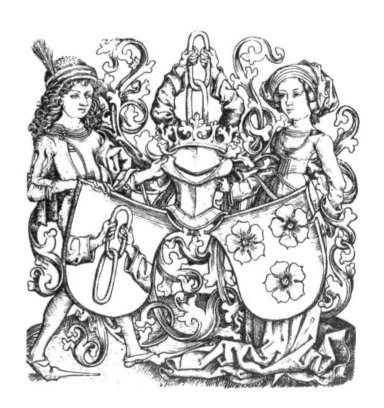

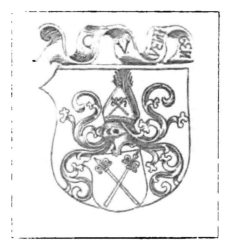

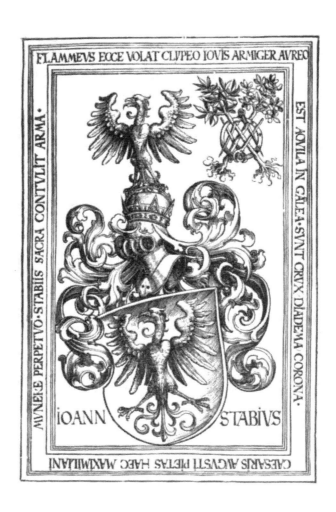

FLAMMEVS ECCE VOLAT CLYPEO IOVIS ARMIGER AVREO

EST AQVILA IN GALEA·SVNT CRVX DIADEMA CORONA·

AVNELÆ PERPETVO·STABIIS SACRA CONTVLIT ARMA·

IOANN STABIVS

CAESARIS AVGVSTI PIETAS HAEC MAXIMILIANI

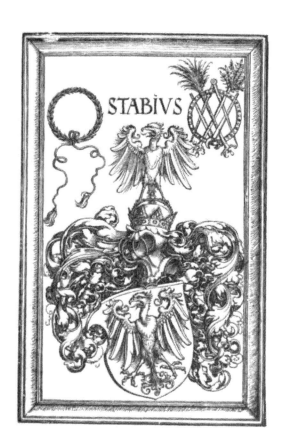

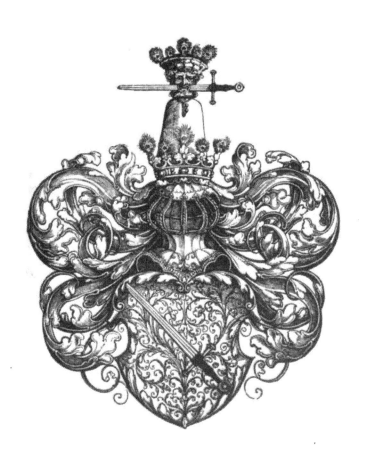

BALTH SARDEIGRÃPPTVS
ETARCHIDIA ⌐ONVS ECCLIÆ
SALCZBVRGENSIS

1529

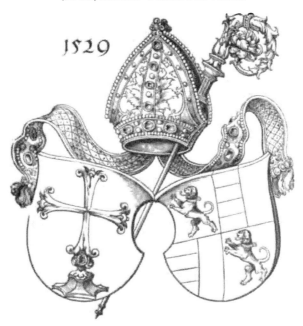

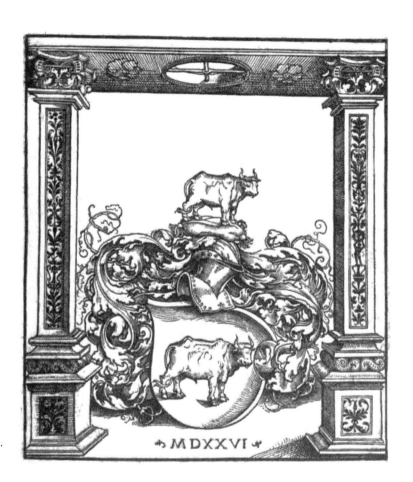

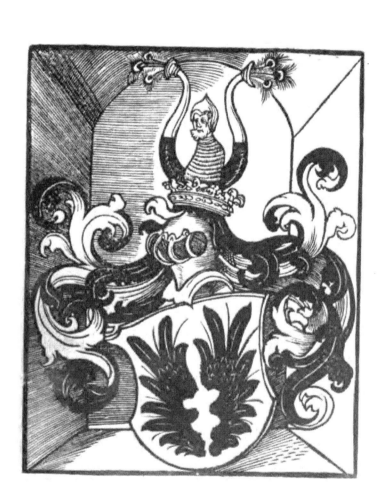

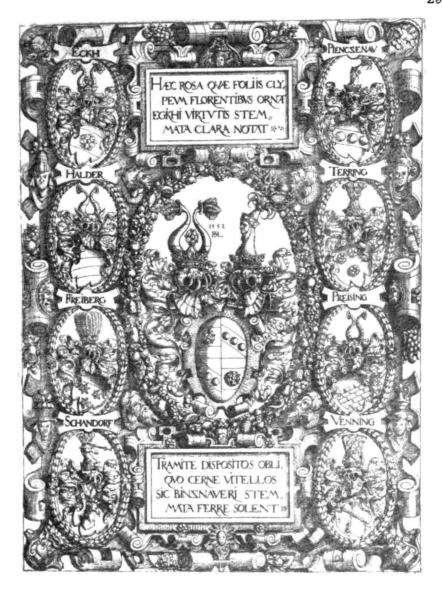

HÆC ROSA QVÆ FOLIIS CLY,
PEVM FLORENTIBVS ORNAT
EGKHÍ VIRTVTIS STEM,
MATA CLARA NOTAT

TRAMITE DISPOSITOS OBLI,
QVO CERNE VITELLOS
SIC BINSNAVERI STEM,
MATA FERRE SOLENT

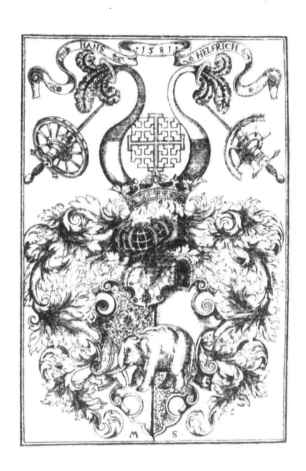

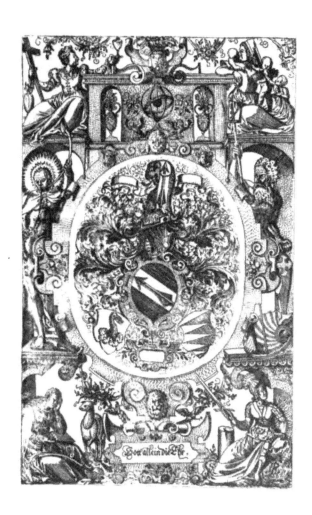

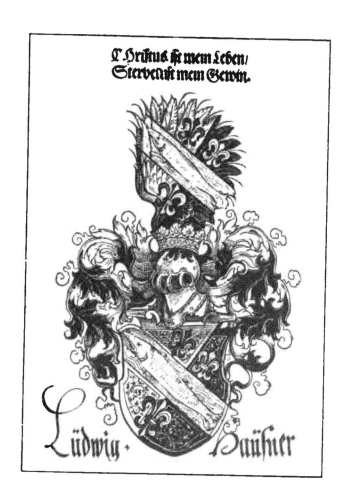

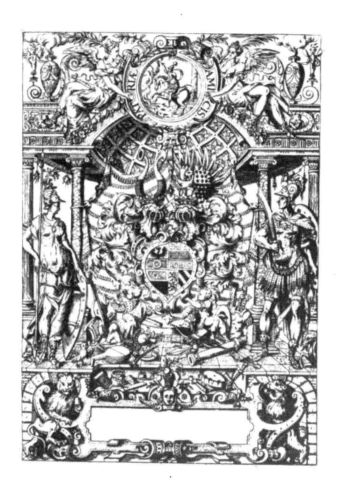

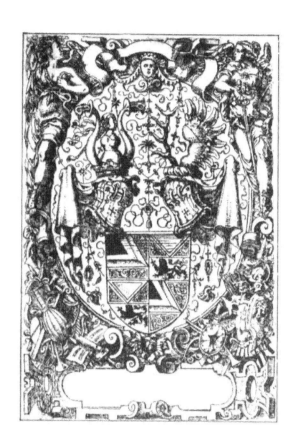

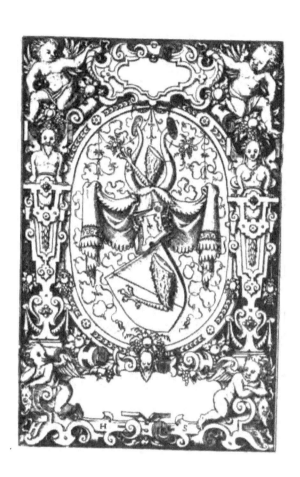

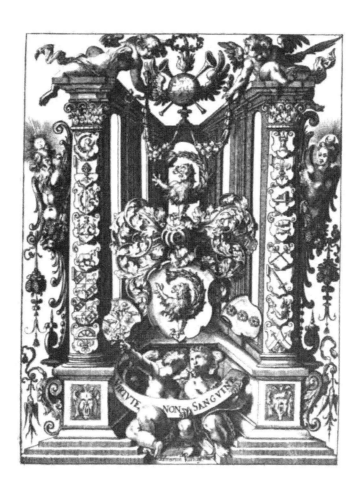

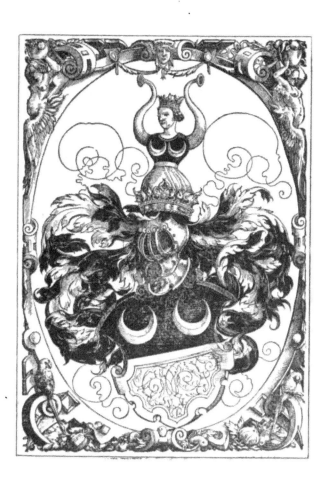

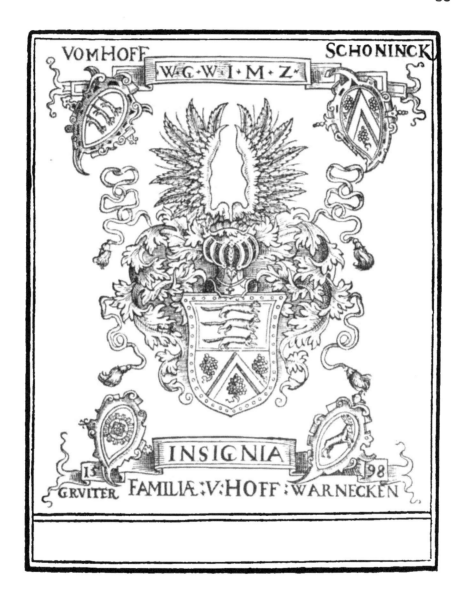

VOMHOFF SCHONINCK

W·G·W·I·M·Z·

INSIGNIA

15 98

GRVITER FAMILIÆ·:V·HOFF·:WARNECKEN

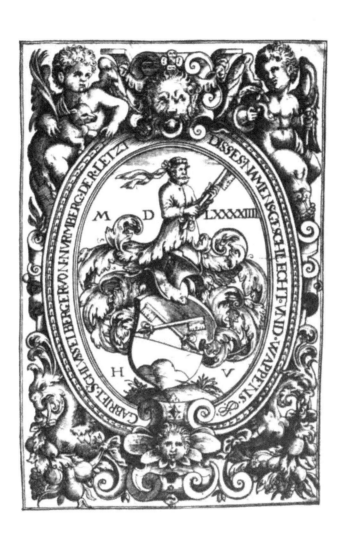

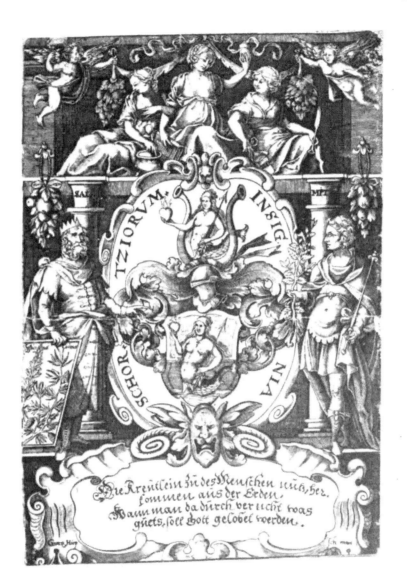

RARE BOOK-PLATES

(EX-LIBRIS)

OF THE

XVTH AND XVITH CENTURIES,

BY

ALBERT DUERER, H. BURGMAIR, H. S. BEHAM, VIRGIL SOLIS, JOST AMMAN ETC.

EDITED

BY

FREDERICK WARNECKE.

THIRD SERIES.

LIMITED *EDITION.*

LONDON

H. GREVEL & Co.

33 KING STREET, COVENT GARDEN, W. C.

MDCCCXCIIII.

(PRINTED IN GERMANY.)

Book-Plate of W. von Rehlingen in Augsburgh.

RARE BOOK-PLATES
(EX-LIBRIS)
OF THE
XVTH AND XVITH CENTURIES,
BY
ALBERT DUERER, H. BURGMAIR, H. S. BEHAM,
VIRGIL SOLIS, JOST AMMAN ETC.

EDITED
BY
FREDERICK WARNECKE.

THIRD SERIES.

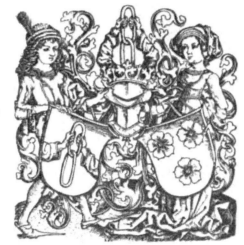

LIMITED *EDITION.*

LONDON
H. GREVEL & Co.
33 KING STREET, COVENT GARDEN, W.C.
MDCCCXCIIII.

(PRINTED IN GERMANY.)

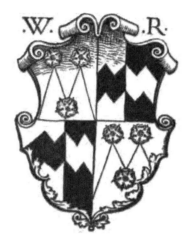

Book-Plate of W. von Rehlingen in Augsburgh.

Plate.	Artist.	Made for:	Date.	Original-size	Warnecke's Herald. Kunstblätter No.
XLI.	*Albert Duerer.*	Jacob de Banissis.	15..	25,5×18,1 cm.	33.
XLII.	*Ditto.*	Willibald Pirkheimer at Nuremberg.	150.	15×11,9 cm.	28.
XLIII.	*Ditto.*	Pömer von Diepoldsdorf at Nuremberg.	15..	16,1×11,2 cm.	112.
XLIV.	*School of Albert Duerer.*	Beham von Schwarzbach (Nuremberg Patrician).	15..	12,5×10,6 cm.	47.
XLV.	*Albert Duerer.*	Florian Waldauf von Waldenstein.	150.	33,1×14,4 cm.	110.
XLVI.	*Lucas Cranach.*	Christoph Scheurl von Defersdorf and his wife Helena Tucher at Nuremberg.	15..	16,4×12,6 cm.	52.
XLVII.	*School of Albert Duerer.*	Philipp Count palatine at Rhine, Bishop of Freiberg and Naumburgh.	151.	24,8×20,8 cm.	111.
XLVIII.	*Hans Burgmair.*	Wolfgang von Gruenenstein, Abbot at Kempten.	15..	45×36 cm.	129.
XLIX.	*Hans Burgmair.*	Unknown.	15..	23,9×15,5 cm.	225.
L.	*Ditto.*	von Mallendein-Heumann.	15..	48×36 cm.	23.

Plate.	Artist.	Made for:	Date.	Original-size.	Warnecke's Herald. Kunstblätter No.
LI.	*Hans Burgmair.*	Unknown.	15..	14,5×11,2 cm.	217.
LII.	*Barthel Beham.*	Hieronymus Baumgaertner, celebrated lawyer at Nuremberg.	153.	6,7×5,1 cm.	62.
LIII.	*School of Albert Duerer.*	Schweigger (from Schwaebisch-Hall).	15..	39,5×27 cm.	51.
LIV.	*Unknown Master.*	Erasmus Waldstromer von Reichelsdorff. (Nuremberg Patrician.)	1555	32,5×26 cm.	241.
LV.	*Ditto.*	Jacob Christoph von Uttenheim.	1559	10,3×8,3 cm.	..
LVI.	*Virgil Solis.*	Wolfgang, Count palatine at Rhine, Duke in Bavaria.	155.	21,8×14,5 cm.	158.
LVII.	*Jost Amman.*	Dr. jur. Johann Wolfgang Freymon from Oberhausen.	1574	20×15 cm.	80.
LVIII.	*Ditto.*	von Welser at Neuenhof. (Nuremberg Patrician.)	15..	11,1×7,2 cm.	82.
LIX.	*Ditto.*	Johann III. Egenolph von Knoeringen, Bishop of Augsburgh.	157.	18,1×17,1 cm.	165.
LX.	*Hans Sibmacher (?).*	von Huelss (Huelsen).	159.	12,2×8 cm.	—

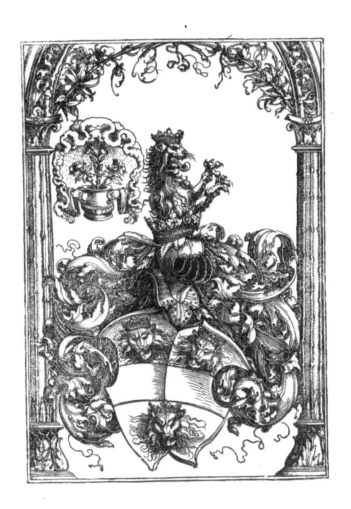

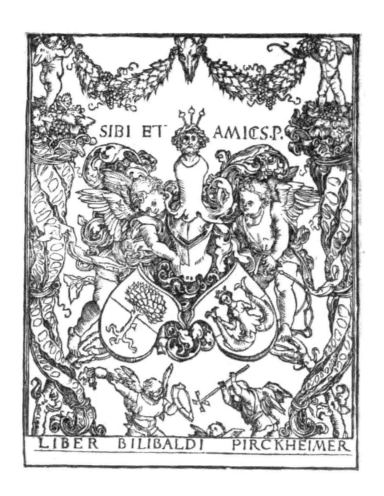

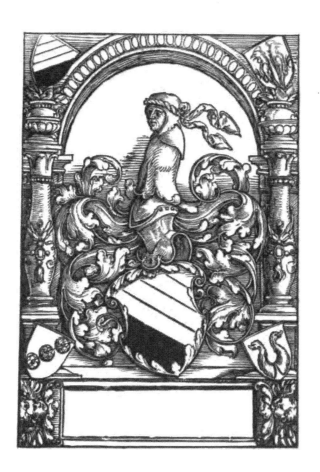

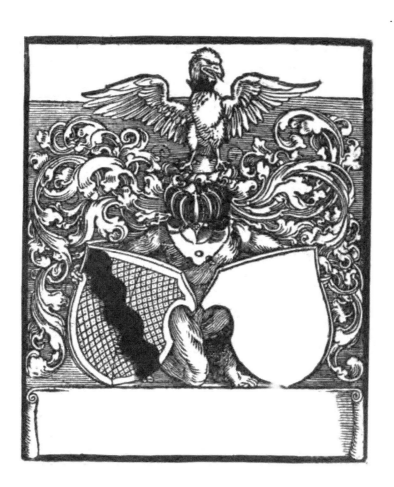

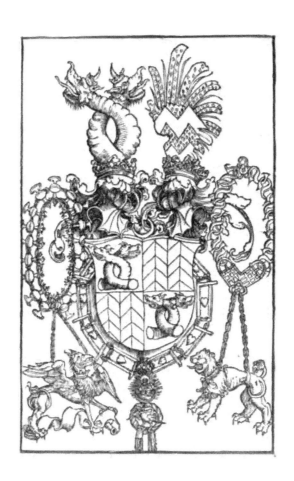

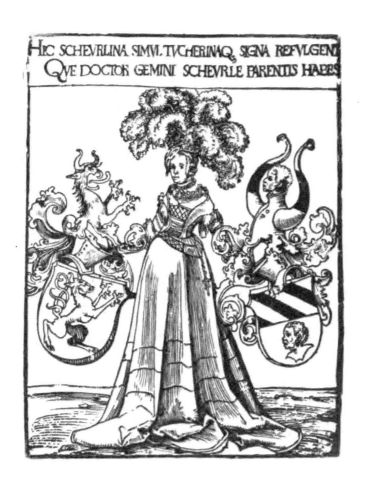

HIC SCHEVRLINA SIMVL TVCHERINAQ SIGNA REFVLGENT
QVE DOCTOR GEMINI SCHEVRLE PARENTIS HABES

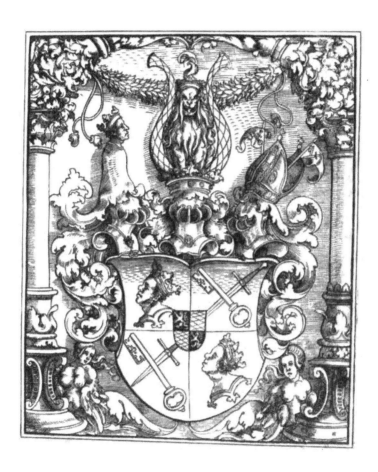

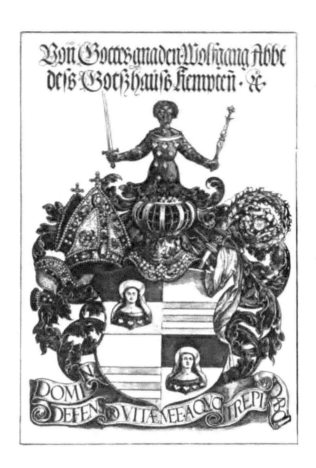

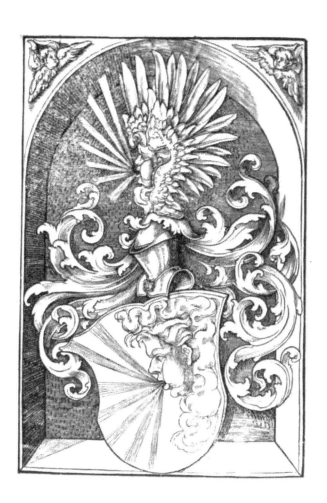

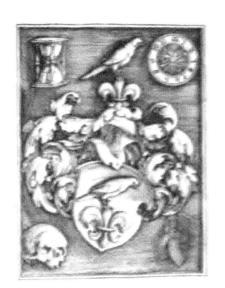

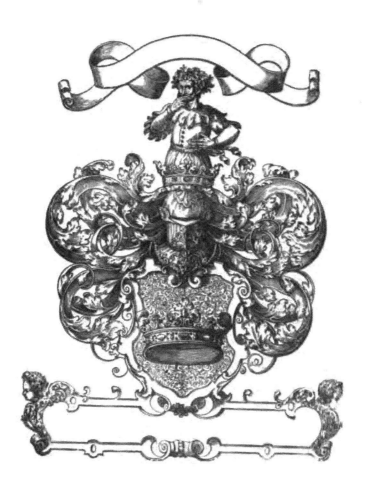

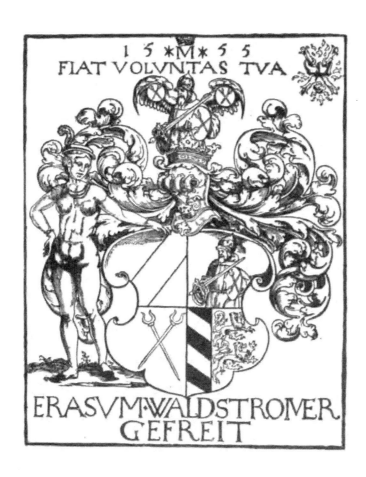

15 *M* 55
FIAT VOLVNTAS TVA

ERASVM·WALDSTROMER
GEFREIT

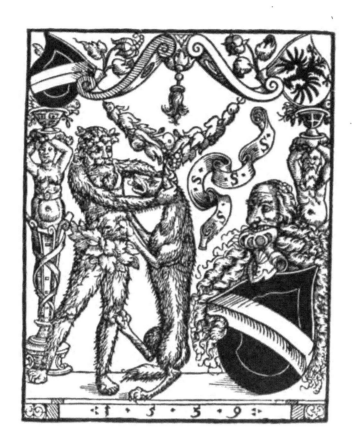

Jacob Chꝛiſtoff von Otten=
heim zů Ramſtein/꙼.
1 5 5 9.

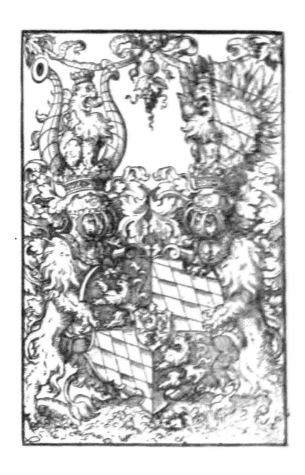

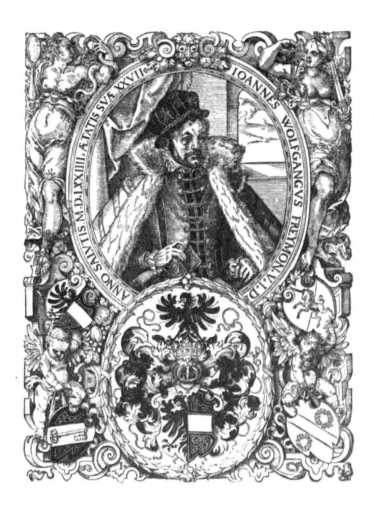

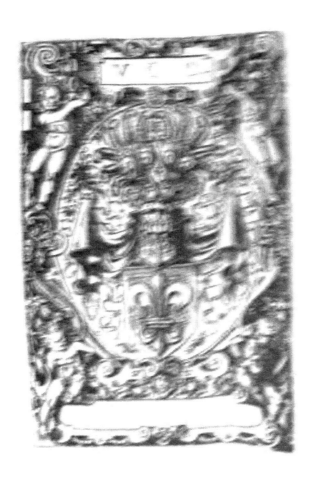

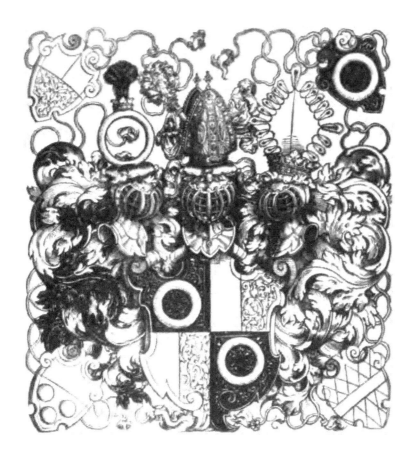

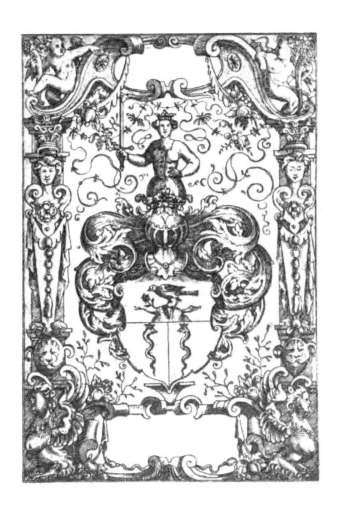

Monogram-Book-Plate E. G. (XVI Century.)

RARE BOOK-PLATES
(EX-LIBRIS)
OF THE
XVTH AND XVITH CENTURIES,
BY
ALBERT DUERER, H. BURGMAIR, H. S. BEHAM, VIRGIL SOLIS, JOST AMMAN ETC.
EDITED
BY
FREDERICK WARNECKE.

FOURTH SERIES.

LIMITED *EDITION.*

LONDON
H. GREVEL & Co.
33 KING STREET, COVENT GARDEN, W.C.
MDCCCXCIIII.
(PRINTED IN GERMANY.)

Book-Plate of W. von Rehlingen in Augsburgh.

Plate.	Artist.	Made for:	Date.	Original-size.	Warnecke's Herald. Kunstblätter No.
LXI.	*Albert Duerer.*	Hieronymus Ebner von Eschenbach and his wife, née Fuerer von Haimendorf at Nuremberg.	1516	12,9×9,7 cm.	41.
LXII.	*Ditto.*	Michel Behaim von Schwarzbach (Nuremberg Patrician).	(1509)	27,2×17,2 cm.	31.
LXIII.	*Ditto.*	Hector Poemer, Chaplain at S. Laurent in Nuremberg.	1521	29,5×19,6 cm.	39.
LXIV.	*School of Albert Duerer.*	Scheurl von Defersdorf and his wife, née Tucher.	15..	29,7×20,3 cm.	50.
LXV.	*Hans Holbein (?).*	D. G. Hauer.	15..	13,6×8,7 cm.	—
LXVI.	*Unknown Master.*	Leonhard von Keutschach, Archbishop of Salzburgh.	151.	25,1×17 cm.	199.
LXVII.	*Ditto.*	Johann III. von Schoenberg Bishop of Naumburgh.	151.	13,6×8,7 cm.	113.
LXVIII.	*Hans Leonhard Schaeufelin.*	Hartmann Schedel at Nuremberg, author of the Nuremberg Chronicle.	15..	21,8×16,5 cm.	58.
LXIX.	*Hans Burgmair.*	Unknown.	15..	49×37 cm.	131.
LXX.	*School of Albert Duerer.*	Lazarus Spengler at Nuremberg.	153.	13,5×9,1 cm.	48.

Plate.	Artist.	Made for:	Date.	Original-size:	Warnecke's Herald. Kunstblätter No.
LXXI.	*Hans Burgmair.*	Cardinal Bernhard von Cless, Bishop of Trent.	15..	47×39 cm.	128.
LXXII.	*Unknown Master.*	Hans Baron Gaudenz von Madrutz.	15..	54×35,6 cm.	133.
LXXIII.	*Ditto.*	Dr. M. Klostermair.	152.	18,7×14 cm.	—
LXXIV.	*Ditto.*	Sebastian Hoeflinger in Imolkam (Austria), Dr. jur.	15..	49,4×35,3 cm.	135.
LXXV.	*Ditto.*	Hieronymus Rodler Secretary at Siemeren.	1531	15,2×13,2 cm.	123.
LXXVI.	*Ditto.*	Johann Adler.	15..	11,7×8,4 cm.	201.
LXXVII.	*Hans Burgmair. the Younger.*	Otto Heinrich and Philipp, Counts palatine in Bavaria.	154.	50×40 cm.	132.
LXXVIII.	*Unknown Master.*	Wolf Haller von Raitenbuech. (Bavarian nobleman.)	1555.	23×16,7 cm.	152.
LXXIX.	*Ditto.*	Joachim Heller from Weissenfels.	15..	12×8 cm.	—
LXXX.	*Matthias Zuendt.*	Pfinzing von Henfenfeld. (Nuremberg Patrician.)	15..	18,3×12 cm.	78.

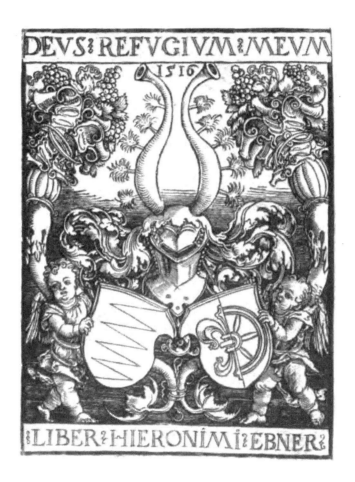

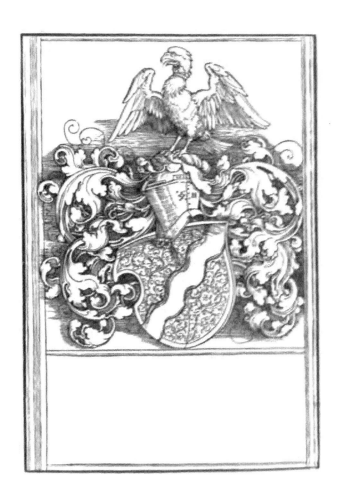

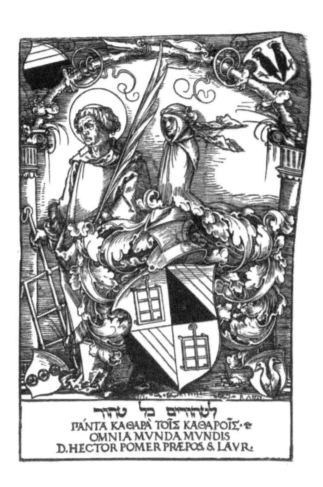

לטהורים כל טהר

ΓΑΝΤΑ ΚΑΘΑΡΑ ΤΟΙΣ ΚΑΘΑΡΟΙΣ.
OMNIA MVNDA MVNDIS
D. HECTOR POMER PRÆPOS. S. LAVR.

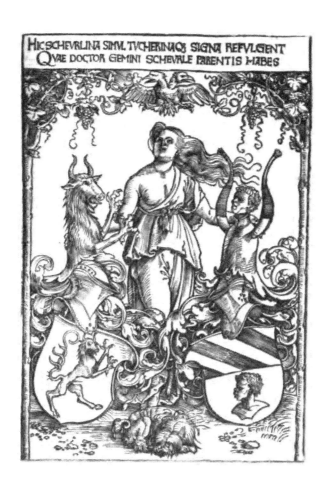

HIC SCHEVRLINA SIMVL TVCHERINAOS SIGNA REFVLGENT
QVAE DOCTOR GEMINI SCHEVRLE PARENTIS HABES

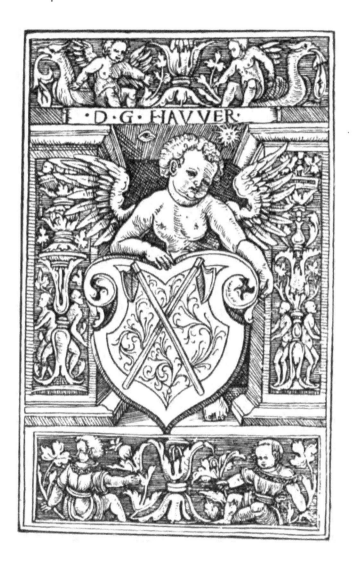

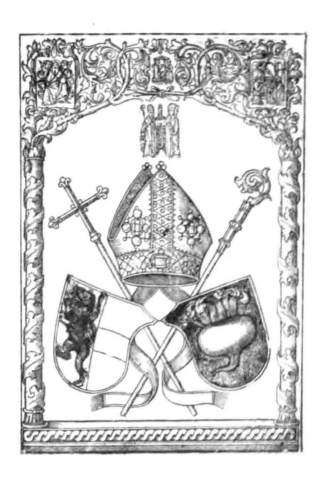

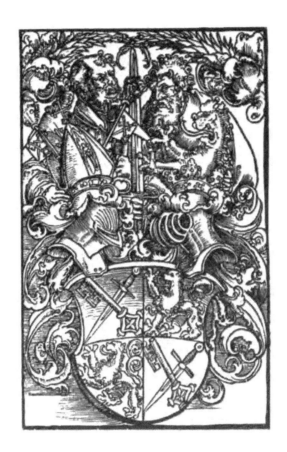

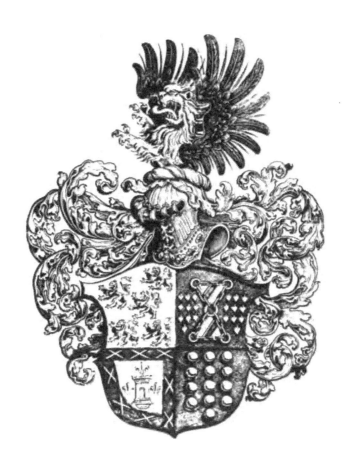

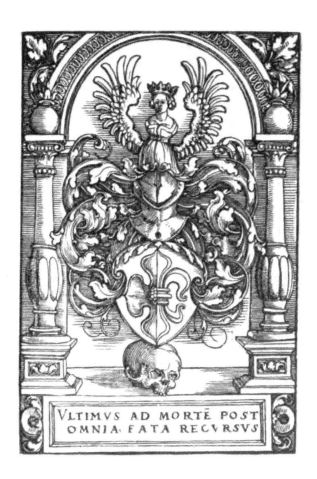

ULTIMVS AD MORTÉ POST
OMNIA FATA RECVRSVS

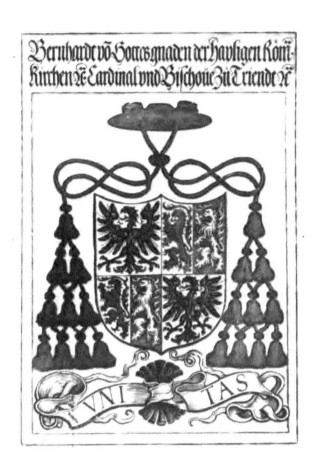

Hanns Gaudentz freyherz zw
Madrutsch. lup vnd Brentonigie

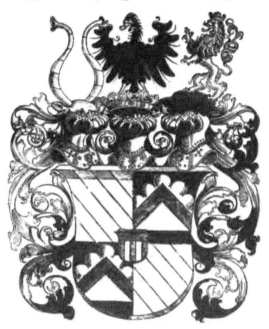

M K · 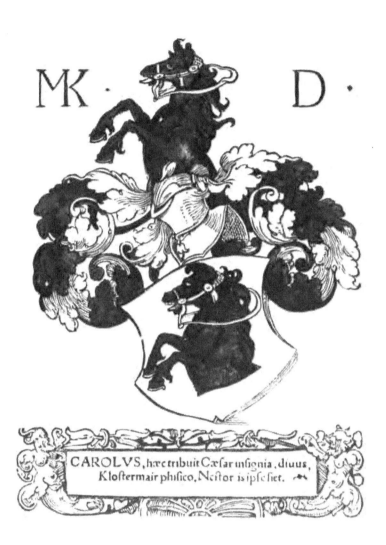 D ·

CAROLVS, hæc tribuit Cæfar infignia, diuus,
Kloftermair phifico, Neftor is ipfe fiet.

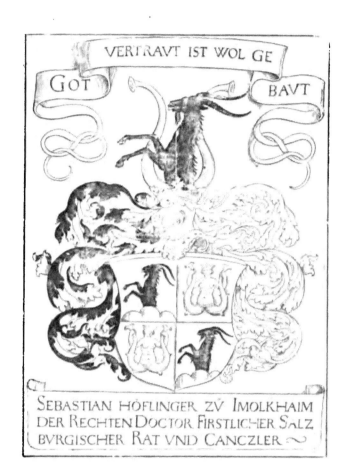

VERTRAVT IST WOL GE

GOT

BAVT

SEBASTIAN HÖFLINGER ZV IMOLKHAIM
DER RECHTEN DOCTOR FIRSTLICHER SALZ
BVRGISCHER RAT VND CANCZLER

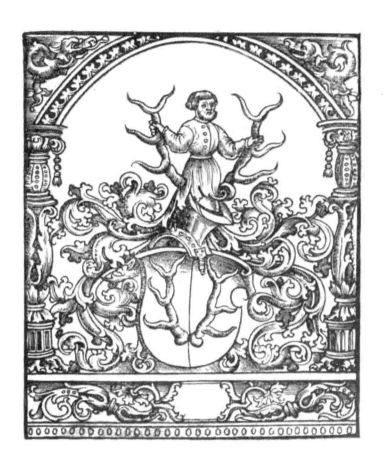

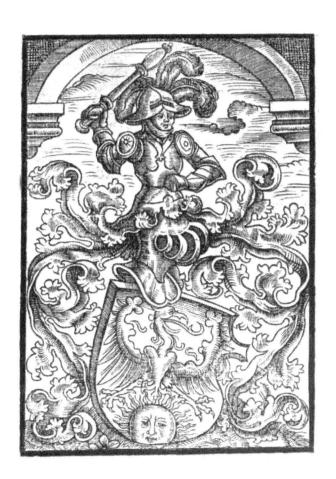

Ott Hainrich vnd Philips gebrüdere.
Gottes genaden Pfaltzgrauen beim Rein.
Hertzogen in Nidern vnd Obern Bairñ⸗

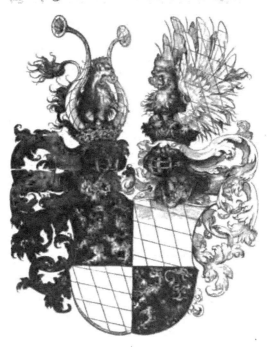

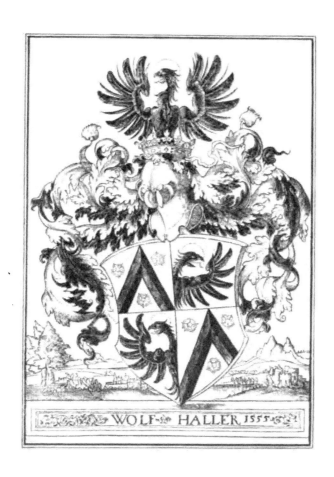

INSIGNIA IOACHIMI HELLERI
Leucopetræi,

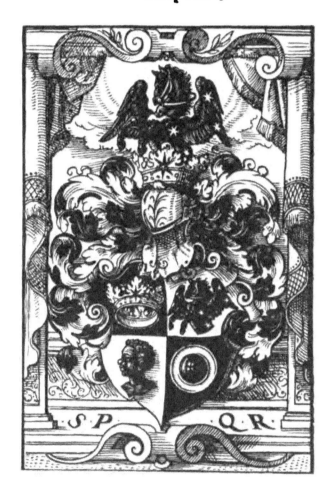

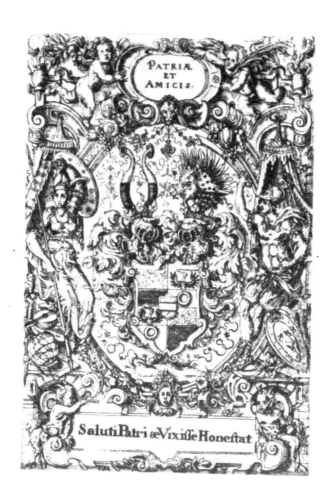

Monogram-Book-Plate E. G. (XVI Century.)

RARE BOOK-PLATES
(EX-LIBRIS)
OF THE
XVTH AND XVITH CENTURIES,
BY
ALBERT DUERER, H. BURGMAIR, H. S. BEHAM,
VIRGIL SOLIS, JOST AMMAN ETC.
EDITED
BY
FREDERICK WARNECKE.

FIFTH SERIES.

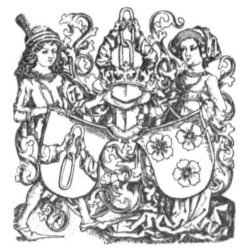

LIMITED *EDITION.*

LONDON
H. GREVEL & Co.
33 KING STREET, COVENT GARDEN, W.C.
MDCCCXCIIII.
(PRINTED IN GERMANY.)

Book-Plate of W. von Rehlingen in Augsburgh.

Plate.	Artist.	Made for:	Date.	Original-size.	Warnecke's Herald. Kunstblätter No.
LXXXI.	*Unknown Master.*	The Chapter of Benedictbeuren.	15..	16,6×11,3 cm.	—
LXXXII.	*Ditto.*	Jacob Spiegel.	153.	11,2×7,7 cm.	—
LXXXIII.	*Ditto.*	Dr. Martin Eisengrein.	1564	18,1×14 cm.	—
LXXXIV.	*Monogrammist I. K.*	Franz Gottfried von Troilo.	15..	18,4×13,5 cm.	—
LXXXV.	*Monogrammist C. B.*	von Roggenbach.	1543	14,2×10,3 cm.	—
LXXXVI.	*Monogrammist T H V B.*	Dr. Bartholomaeus Matzler.	15..	13×8,3 cm.	—
LXXXVII.	*Jost Amman.*	Johann Aegolph von Knoeringen, Canon at Wuerzburgh.	156.	22,1×15,4 cm.	—
LXXXVIII.	*Unknown Master.*	Johannes Dulcius.	1573	16×11 cm (?).	—
LXXXIX.	*Jost Amman.*	Salomon Schweigger.	15..	14,5×10,5 cm.	—
XC.	*Ditto.*	Johann Fischart, alias Mentzer.	158.	12,9×8,8 cm.	—

Plate.	Artist.	Made for:	Date.	Original-size:	Warnecke's Herald. Kunstblätter No.
XCI.	*Jost Amman.*	Gugel von Diegelsdorf (Nuremberg Patrician) and his wife, née Muffel of Ermreuth.	15..	9,4×7,2 cm.	81.
XCII.	*Virgil Solis.*	Erasmus Rauchschnabel.	1562	9,8×7,5 cm.	72.
XCIII.	*Unknown Master.*	Caspar Neuboeck, Bishop of Vienna.	157.	13,6×9,2 cm.	—
XCIV.	*Ditto.*	M. Abraham Nagel from Gemuend.	15..	18,3×17,2 cm.	—
XCV.	*(David Kondel.)*	Georg Kandel.	15..	12,3×8,8 cm.	—
XCVI.	*Bartholomaeus Reiter.*	Zacharias Starck.	1582	11×7,3 cm (?).	—
XCVII.	*Hans Sibmacher(?)*	Andreas Beham the Elder.	1595	11,3×7,7 cm.	—
XCVIII.	*Unknown Master.*	Erhard-Clery.	159.	8,8×8,3 cm.	—
XCIX.	*Heinr. Ullrich.*	Clemens Resen.	159.	11,1×8,1 cm.	—
C.	*Unknown Master.*	Melchior Klesel, Cardinal, Minister of Emperor Matthias.	1613	30,5×19 cm.	—

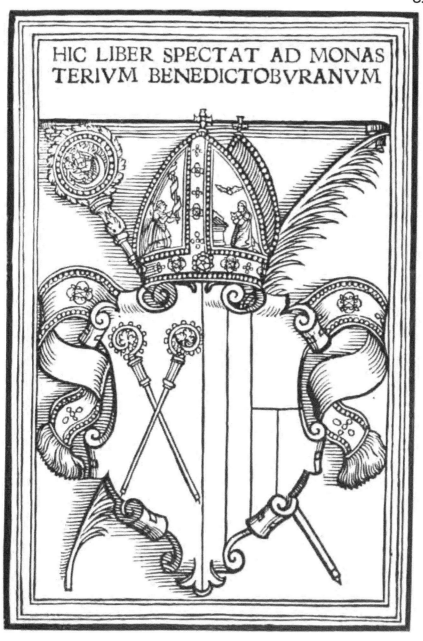

HIC LIBER SPECTAT AD MONAS
TERIVM BENEDICTOBVRANVM

INSIG. IAC. SPIEGEL
SELESTADIEN.

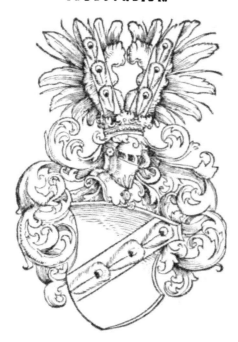

Quum peterem, tantum laudaret Cæsar auitum
 Infigne, exorno hoc te, Maxmilianus ait,
Atque inter cretos longæua nobilitate
 Scribæque arcani te uolo habere locum.
Carolus Hefperiæ Rex, poftquā auus aftra petiuit
 Qua prius, admittit conditione fruar,
Vt Cæfar dictus, cenfum dat, meqʒ fidelem
 Effe iubet feruum, dum mihi uita manet,
Confpicuumqʒ facit, Sacræ largitus honorem
 Aulaï Comitum fplendidiore toga.

TECVM HABITA.

1 5 6 4.

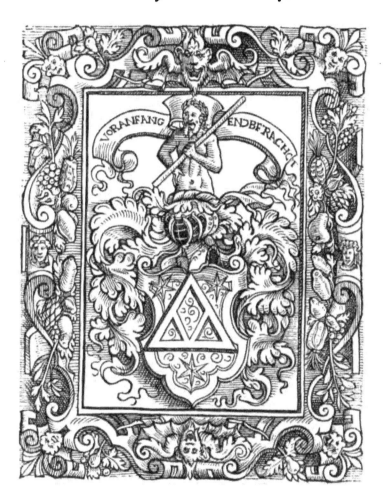

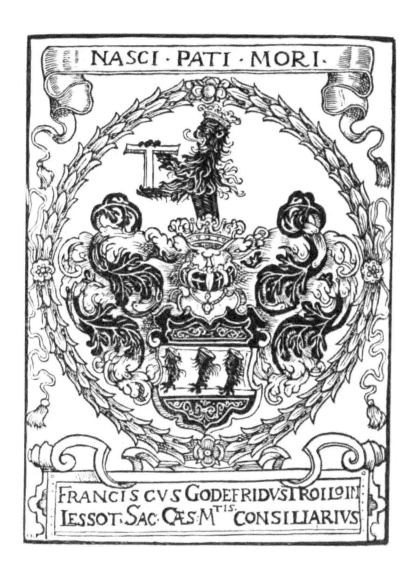

NASCI · PATI · MORI ·

FRANCISCVS GODEFRIDVS TROILO IN
IESSOT · SAC · CÆS · M^{TIS} · CONSILIARIVS

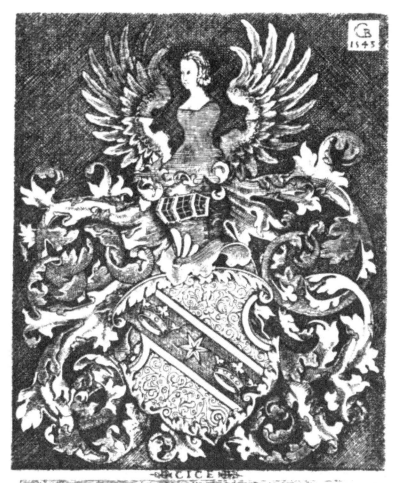

CICE

MAGNVM EST EADEM HABERE MONVMENTA
MAIORVM, IISDEM VTI SACRIS, SEPVLCHRA
HABERE COMMVNIA: NIHIL AVTEM AMABILI-
VS QVAM MORVM SIMILITVDO BONORVM.

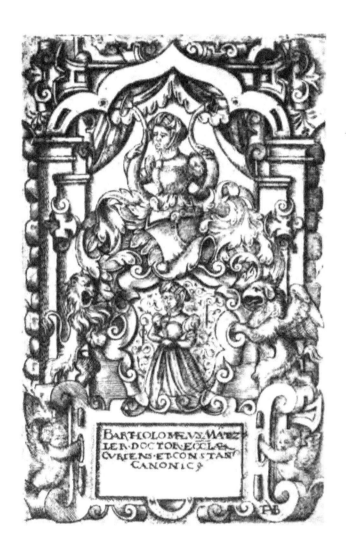

BARTHOLOMEVS MAYE
LER DOCTOR ECCLA
CVRIENS ET CONSTAN
CANONIC 9

AD INSIGNIA REVE-
ENDI NOBILITATIS VETVSTATE ET
DOCTRINA PRAESTANTIS VIRI. IOHANNIS ÆGOL-
phi à Knöringen, VVirtzeburgensis Ecclesiæ Canonici, Et Augustani
Custodis, patroni sui obseruandi, Hartmannus Schop-
perus Nouisorensis.

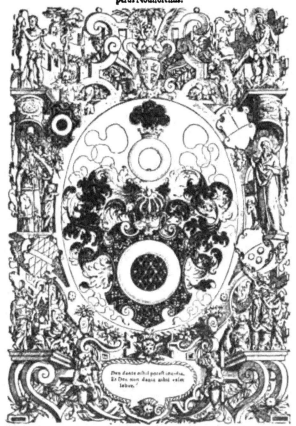

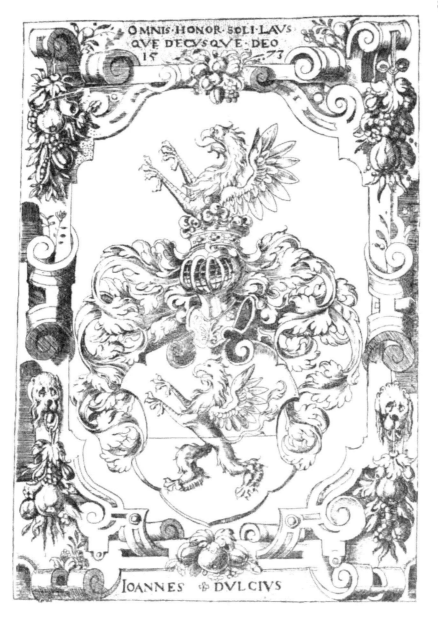

SALOMON SCHWEIG·
GER SVLTZENSIS.

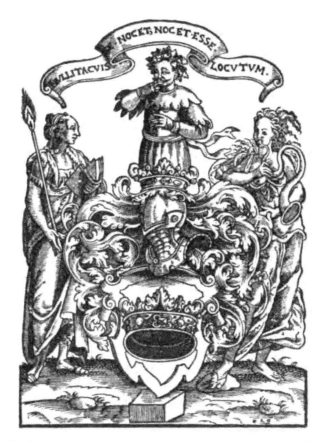

Quadrati lapidis similis sit vir bonus, in omni tribulatione non cadit, & si qua im-
pellitur, & si qua vertitur, non cadit, stantem te inveniat omnis casus.

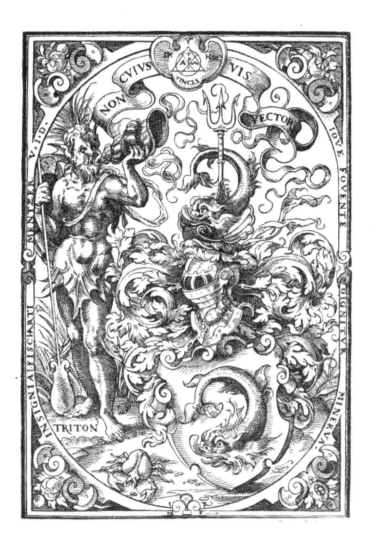

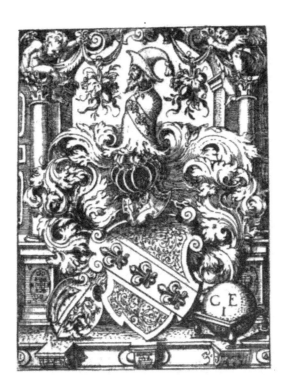

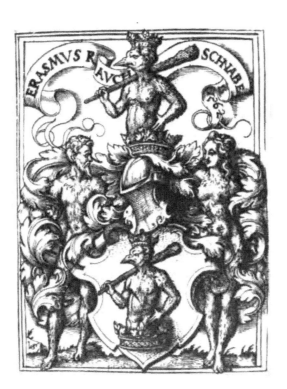

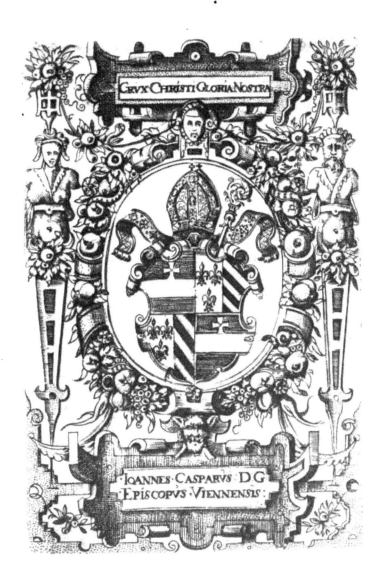

CRVX·CHRISTI·GLORIA·NOSTRA

IOANNES·CASPARVS·D·G
EPISCOPVS·VIENNENSIS·

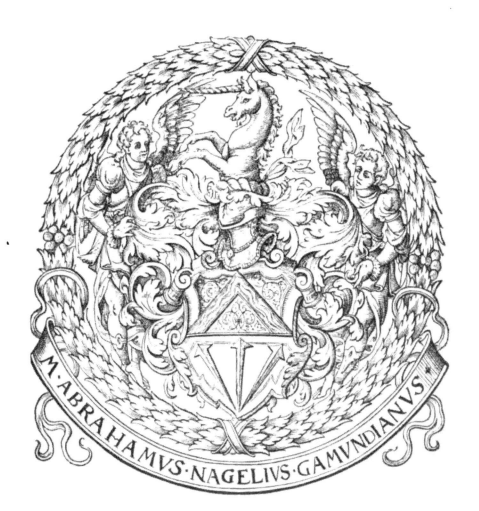

M·ABRAHAMVS·NAGELIVS·GAMVNDIANVS·

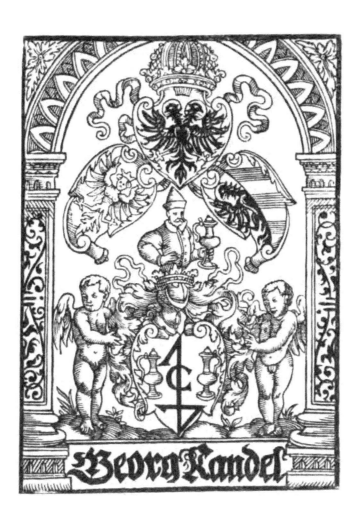

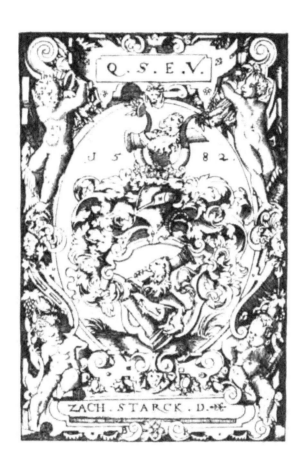

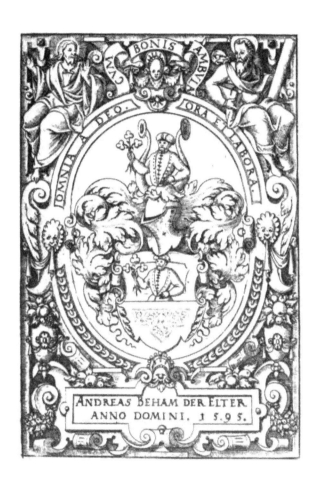

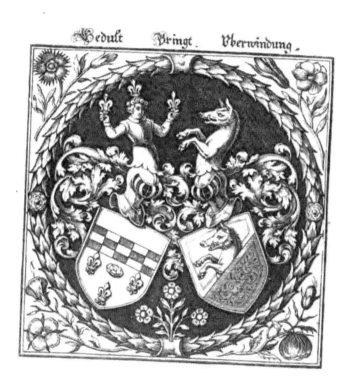

Gedult Bringt Vberwindung.

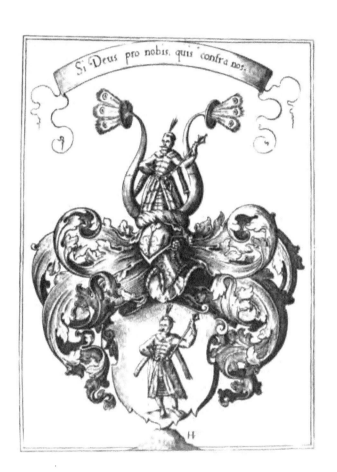

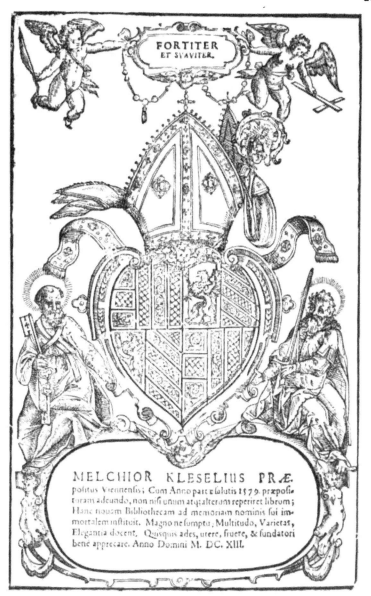

FORTITER ET SVAVITER.

MELCHIOR KLESELIUS PRÆ-
positus Viennensis; Cum Anno partæ salutis 1579. præposi-
turam adeundo, non nisi unum atq́.alterum reperiret librum;
Hanc nouam Bibliothecam ad memoriam nominis sui im-
mortalem instituit. Magno ne sumptu, Multitudo, Varietas,
Elegantia docent. Quisquis ades, utere, fruere, & fundatori
bene apprecare. Anno Domini M. DC. XIII.

Monogram-Book-Plate E. G. (XVI Century.)

Lightning Source UK Ltd.
Milton Keynes UK
UKHW050056090223
416726UK00017B/233